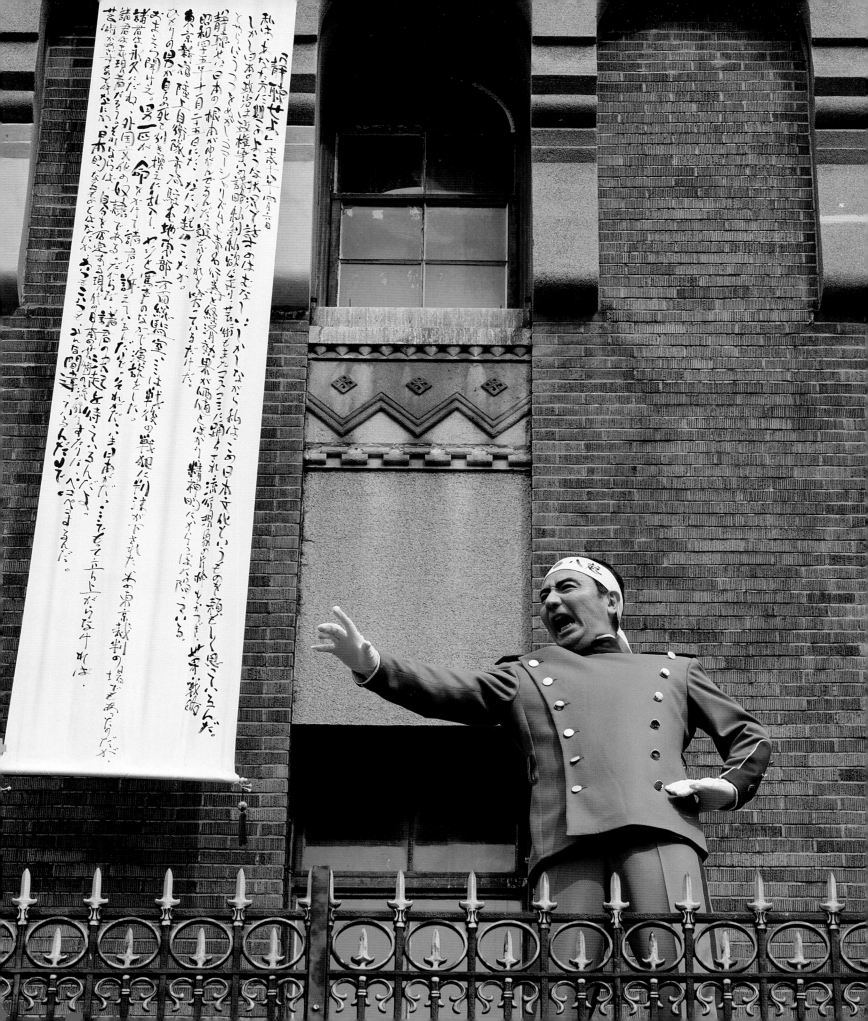

Listen to Me!

Adaptation of a speech by Yukio Mishima

Quiet! Listen to me! I am telling you to be quiet! Don't you get it? I am telling you, be quiet and listen to me!

It may be pointless for me to speak to you like this. But I have faith, I have faith in Japanese culture.

Yet Japanese politics has become nothing but power struggles and plots, a race for private gain and personal ambition; art, too, is dancing to the tune of the mass media, a handmaiden of fads and fashion, drunk on global strategies and commercialism and selling itself out; economic gain is now the only value, we are spiritually bankrupt.

Be quiet! Listen to me! Be quiet, I say!

Japan's soul has been deformed. And everyone just laughs it off. And you know what? Do you know what happened on November 25, 1970? 1970, and I don't mean the World's Fair!

Tokyo. Shinjuku Ward. Ichigaya Headquarters of the Ground Self Defense Forces. They handed down the verdicts in the Tokyo War Crimes Trials here, too. But I am talking about a man who gave his life to force his way in and give a speech here, amid a chorus of jeers and curses.

You listen to me! Shut up and listen! Listen to what I'm saying! Listen to a man who is giving his life to try to get through to you! Come on! Listen!

So, Japan today, if we don't rise up, if you don't, too, we'll be eternal slaves of foreign culture. Running dogs of foreign armies. That's why, that's why I am waiting for you, waiting for you all to rise up!

You are artists, aren't you? If you are, why is it you are so enthralled with forms of expression that deny who you are? Why do you kiss the ass of every passing fad and fancy in Japanese art today, as they undermine your identity? If you keep on like this, nothing can ever save you, nothing.

The world is overrun with sick culture. Tell me, what is the purpose of art? What is it that makes something Japanese? You are all deluded, all of you. You and you and you – all deluded. Can't you see that? Isn't there a single one of you who will join me and rise up?

All right. I see. I can see that not one of you will rise up in the cause of art. With this my faith in art is at an end. All I can do is shout "Banzai!"

Banzai! Banzai! Banzai! Banzai! Long Live Art! Banzai! Banzai! Banzai!

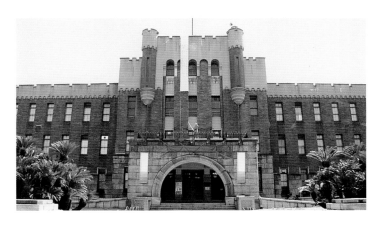

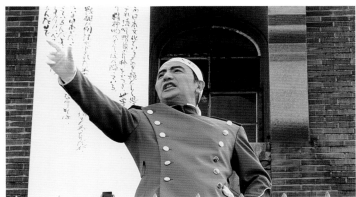

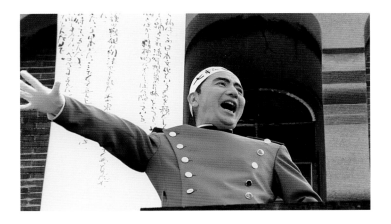

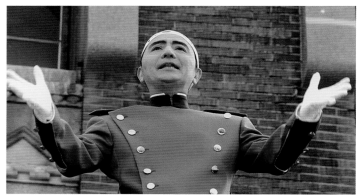
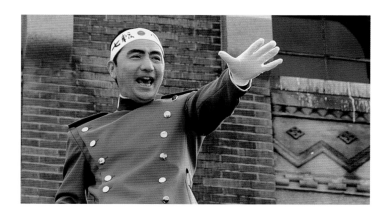

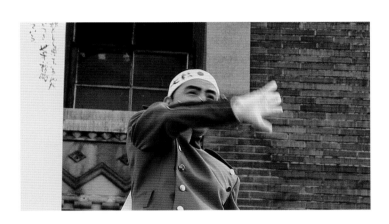

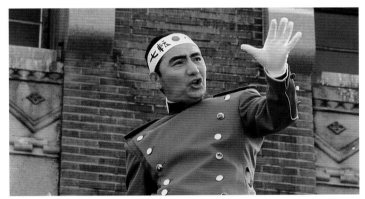

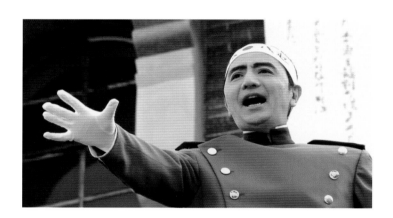

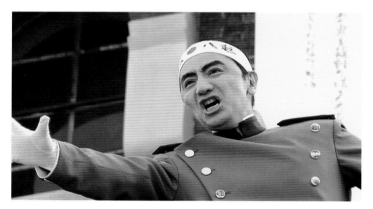

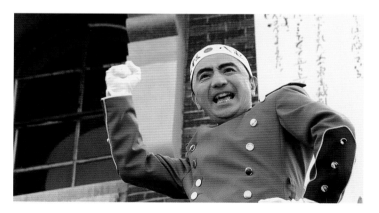

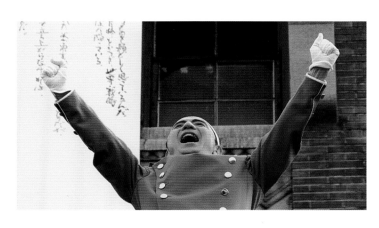

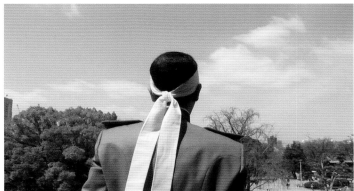

YASUMASA

MORIMURA

Requiem for the XX Century
Twilight of the Turbulent Gods

Edited by
Filippo Maggia
Marinella Venanzi

SKIRA

Cover
A Requiem: Red Dream /
Mao, 2007
C print mounted on alpolic, colour
120 × 150 cm

Art Director
Marcello Francone

Design
Luigi Fiore

Editorial Coordination
Marzia Branca

Editing
Laura Guidetti

Layout
Paola Pellegatta

Translations
Jennifer Knable
Lexiconline

First published in Italy in 2008
by Skira Editore S.p.A.
Palazzo Casati Stampa
via Torino 61
20123 Milano
Italy
www.skira.net

Printed and bound in Italy.
First edition

ISBN: 978-88-6130-299-0

Distributed in North America by
Rizzoli International Publications,
Inc., 300 Park Avenue South,
New York, NY 10010, USA.
Distributed elsewhere in the
world by Thames and Hudson
Ltd., 181A High Holborn,
London WC1V 7QX, United
Kingdom.

The first edition of this volume
has been published for the
exhibition *Yasumasa Morimura.
Requiem for the XX Century.
Twilight of the Turbulent Gods*,
Fondazione Bevilacqua La Masa
Galleria di Piazza San Marco,
Venice, 8 June – 8 October 2007

Contents

4 Listen to Me!
 Adaptation of a speech by Yukio Mishima

17 Encounter with the West
 Angela Vettese

21 Yasumasa Morimura: Appeasing the Susanoo of Kamagasaki
 Kai Itoi

38 Mr. Morimura's Dictator Speech

45 Banzai! Banzai! Banzai! Banzai! Long Live Art! Banzai! Banzai!
 Banzai!
 Filippo Maggia

64 A Requiem: Humanity is Sadly Futile

73 List of Works on Exhibit

75 Biography

77 Bibliography

Encounter with the West

Yasumasa Morimura belongs to a Japan which perhaps the very young do not wish to remember. It was a state in which the war had defeated pride, peace and security. The place of the atomic bomb. It was the spot where American originated consumerism began combining with an adaptability to the West which, more than anything else, represented a painful detachment from the past. Perhaps at times an enthusiastic detachment, made by a clear break from ancient customs and anxieties. As Westerners we have been able to read something of this in the writings of Kenzaburo Oe, Tanizaki, or Banana Yoshimoto. Through their books we have given ourselves a vague yet perhaps not inappropriate idea of a new rapport with sex, alcohol, and above all a new ethic which, belonging to the victorious, could not be easily avoided. Hedonism, infantilism, consumerism, tourism, dependence on work and on games. Adoration for movie stars, attempts at emulating their world, a game of mirrors of an East that had remained closed to Western ships longer than any other oriental coast: in such a short time it must have been difficult to rediscover oneself, to the point of driving certain traditions —combined matrimony, adoration of the emperor, male chauvinism—to smoulder under the ashes but with ever fewer rights of finding refuge in international communication.

Then in the 1990s the boom, scandals, and fear of precipitating into a civilization of subsistence. Nevertheless, Tokyo continued to expand out of fear and enthusiasm, vomiting forth from the mouths of trains onto suspended walkways millions of people everyday. In the meantime, the relationship with the conquering West became an increasingly shared one: Italian, French, Belgium, and English fashion were flanked by names like Kenzo, Comme des Garçons, Yoshi Yamamoto, Watanabe and other idols from which resulted, for us, a new exoticism.

Our children become hybrids. But even more so they become the children of a Japan where the machine of desire is grafted in young hybrid bodies, asexual or hypersexual, with a fashion that changes weekly. Light hair, even orange, tanned faces that belie a century-old cult of paleness, adolescents searching for some point of reference in antique religions, as well as in new importations like Christianity.

Morimura has gradually interpreted all the great myths that have been brought to his country from the West. In 1992 he dressed himself as Christ for the

Metropolis exhibition in Berlin. In 1996, for the Hugo Boss section at the Guggenheim in New York, he appeared as Marilyn and Gilda. We have also seen him as Frida Khalo and as many other personages of popular worship.

What adds tragedy to the comic side of these parodies is that attaining any plausible resemblance to such persons is quite impossible: a yellow face with masculine almond-shaped eyes can bear no likeness to the milky skin or round eyes of Marilyn. The artist's short legs do not glide like those of Rita Hayworth towards a sensuality beyond control. In the representation of the Crucifixion we are placed before a man who has no Semitic features at all and hence no rootedness in history.

The game continues with a series of self-portraits where the artist is dressed to resemble less glamorous legends: those of the world of Western ideology such as Che Guevara and Hitler on one hand, and on another that of the great Chinese leader, Mao Tsedong, who learned from the Russians how to make revolution. Science makes fun of us from the tongue-protruding face of an Einstein-Morimura, and along with it so does the entire backbone of our strongest belief, that which was born from the technological-scientific evolution and which, in industrial terms, made Japan great.

Even in these new series, Morimura still appears to us as the sacrificial lamb. He theatrically stages the strain of confronting a world which cannot be disregarded and with which contact has been decidedly violent, as well as inevitable.

This explains why now is the moment for re-examining Morimura's work. He faces a political discourse, about both the power in the word and the power in the media. He plays literally with his own skin, putting the very sense of the absurd at stake and trying to see at which point an attempt at maniacal imitation becomes grotesque or neurotic, sick or unresolved. His own vision of not only custom and history, but also of art history, cannot but recommence from the West, to be transported into the East, notwithstanding such bizarre paradoxes such as the fact that Van Gogh learnt to paint from Japanese prints and the Japanese then made great strides to collect his paintings. The tradition that defeats and colonizes minds, for the moment, is just one: that which was born out of the American victories in the two World Wars of the twentieth century.

Things are rapidly changing, however. Now we whites are up against a globalization that places each one of us in the garments of Morimura. We find

ourselves trying to be a bit Chinese, a bit Arab, a bit ourselves. The wound accompanying the grafting, the wrong that pricks the plant when we try giving it a branch and a new gene, is now something we all share. The twentieth century produced stars who merged with our bone structure and who modified, demolished, and crushed it into compulsive and repetitive identities. In addition, our models appear tragically past, and we have no new ones. We here in Europe are growing weary. The era of single cultures has finished and a culture of hybrids has begun. For everyone, Morimura repeats how much this mutation process, which he and his people were the first in the world to face in a radical way, can be disorienting and destructive. His whole oeuvre is focused on the ruptures on the veil of identity, but also, in his last production, on the dangers of a new dictatorship. Beyond any attraction for the genius, the stars, the hero, we should beware regarding how tricky can be the meeting of many cultures and the fight for the domination that it brings in itself.

Kai Itoi

Yasumasa Morimura:
Appeasing the Susanoo of Kamagasaki

Riding a cab from his studio in Tsuruhashi to Kamagasaki, both in Osaka, Yasumasa Morimura was explaining his latest project in his characteristic understated passion. That evening he was going to rehearse the most ambitious shoot of his career. The plan was to reenact the famous Vladimir Lenin speech of May 1920, in the heart of Kamagasaki, Japan's largest slum. And he was recruiting over one hundred day laborers there, many of them homeless, to play the crowd.

Then Morimura said to the cab driver: "We can get off at the Festival Gate; we'll walk from there." The Festival Gate? What is the Festival Gate? Doesn't it sound a bit too ... festive for a landmark of a major slum filled with homeless people?

The Festival Gate used to be an extravagant amusement park, complete with a state-of-the-art roller coaster, a merry-go-round, shops and a cineplex. It cost something like $330 million to build, and took only a few years to fail. Having invested in it early on, the city of Osaka has pumped billions of yen to save it, but to no avail. The very colourful, large sign of "Festival Gate" still stands, however, only a couple of blocks away from the Kamagasaki slum.

A walk from the Festival Gate to Kamagasaki was a backward time travel. Many little bars, bicycle shops, and cheap hotels were crammed in the neighbourhood. It was clear that none of the buildings and houses has been renovated in decades. None was taller than a couple of stories, either. Men were standing around, looking lost, with accumulated fatigue and resignation on their shoulders. It was a world apart from the bustle of the ultramodern downtown Osaka, which is only a few train stops away—or the Festival Gate amusement park.

Morimura took me to a very different kind of park in Kamagasaki, where we saw dozens of men huddle around the open fire to keep warm. They blankly watched news on the ancient CRT-based television set mounted on a pole.

The time stopped there a long time ago. "This is a scene from my childhood," said Morimura, who was born in Tsuruhashi, Osaka, in 1951. Kamagasaki was the place that is still left behind in the 20th century.

Right then and there, it hit me. Morimura was there to appease the Susanoo of Kamagasaki. Susanoo is the God of Storm and Sea, known for violence, in Japanese mythology, and that was what the artist has been tackling since last year.

In a stark contrast with his earlier *Actress* series, in his ongoing series, called *A Requiem*, Morimura replaces and impersonates men in some of the most

memorable and politically-charged images of the 20th century—like Lee Harvey Oswald being shot and Japanese author Yukio Mishima in his failed coup d'etat. Before, Morimura impersonated many gorgeous figures like Marilyn Monroe —in a blonde wig and a white dress à la *Seven Year Itch*—or Frida Kahlo, sporting her massive eyebrows. But there is nothing gorgeous about the *Requiem* series. Suddenly he was making self-portraits as unattractive, unsmiling men in boring dark suits and unflattering military outfits.

When we talked in the fall of 2006, Morimura was comparing the new series to a Japanese Shinto ceremony called *jichinsai*, which a priest performs before a house is built, in order to sanctify the ground and pay respect to what was there before. If you don't do that, the land is cursed.

As Morimura saw it, there were two kinds of beings in the world: ones like Amaterasu, the Sun Goddess, known for warmth and compassion, and others like Susanoo. Morimura, who likened himself to "a daughter of art history," had long identified more with Amaterasu-kind of values and sensitivity.

But now, he was looking at awful historic events that took place in the 20th century—conflicts, wars, genocide, environment disruption, among other things. They were all men's doing, said Morimura, "provoked by the Susanoo in them," as "masculine values led and created the 20th century." By embarking on the new series, he hoped "to dredge up the historic events, place them in my art and appease the Susanoo in them."

Let us go back to Kamagasaki for a moment. Although it was quiet and felt very tired when we visited in March, Kamagasaki has been no sleepy town. Day laborers there had been known to start violent riots over such issues as police handling a homeless man hit by a car. Over twenty major riots occurred throughout the 1960s and early 1970s, which overlaps Morimura's impressionable teenage years. Living in the nearby Tsuruhashi, Morimura often heard about riotous laborers there.

"People said Kamagasaki was a lawless area; it was dangerous, and kids shouldn't go there," he said. "But when you think about it, many Japanese used to live—after the war, for example—the way those in Kamagasaki live today." The scene struck a chord with him because, he said, "it has something to do with my personal memory."

Indeed, the *Requiem* series may be the most personal of Morimura's work.

He deals with the events of the 20th century that were recorded in photography or films and have been in the public—and his own—consciousness.

In 2001, when Morimura revealed the self-portraits as Frida Kahlo, he told me his idea of beauty was "something that stirs up a commotion, which occurs when two different things meet." In the context of the *Requiem* series, Morimura fuses two different things—the historic events which people share as public memory, and his personal recollections—to stir up commotion.

"When historic images provoke recollection, sometimes it causes a commotion in me. When I catch such a moment, it stimulates my enthusiasm for expression, my enthusiasm to produce something that is my idea of 'beauty,'" he said.

As he launched the *Requiem* series last year, it was no surprise that Morimura picked Japanese Yukio Mishima to be the first main figure, given the author's aesthetics and sexual ambiguity. Having read his work since his high school days, Morimura had a great deal of interest in the right wing author.

But Morimura connected more directly with Mishima much later, when he got help from the Japanese Self-Defense Force in 1995. Working on the *Actress* series, he needed an airplane to recreate the famous scene from the movie *Casablanca*. At the Air Self-Defense Force base in Gifu, western Japan, the officers treated Morimura, dressed up as Ingrid Bergman, with respect and adoration. When the shoot was over, "I left there with dignity," Morimura recalled.

Then the artist thought of Mishima, who, in 1970, went to the Self-Defense Force headquarters in Tokyo, trying to launch a coup. He made an impassioned speech, was dismissed by officers, and committed a suicide. "When I was leaving, I thought: 'Mishima couldn't get out; he died there," said Morimura. "He wouldn't have died there at that young age (he was forty-five)—if he had nurtured his feminine side—the Amaterasu in him."

With each of the men he portrays in the series, Morimura had a personal story. He recalled the shock he experienced when he realized that the little red book his smart classmates in high school were carrying around was *Quotations from Chairman Mao Tsedong*. Later, he was shocked again to see the silk-screened portraits of Mao by Andy Warhol. "It's a mixture of fragments of memories," he said. He also remembered other students reading books by Lenin. As for Leon Trotsky, Morimura recalled a Robert Capa exhibition held in the early 1970s in Osaka. There he saw the photograph of Trotsky speaking in Copenhagen in 1932—the work

that made Capa famous. Years later when he was absorbed in "being" Frida Kahlo, Morimura learned of the affair between Kahlo and the Russian revolutionist.

Then, of course, Adolf Hitler. Recreating the dictator's image is obviously a sensitive matter, but "I just could not avoid Hitler, could I, when I was making art about the historic events of the 20th century," said Morimura.

In the end, he decided to refer to how Chaplin impersonated Hitler in the 1940 movie, *The Great Dictator*. Morimura has produced a couple of still photographs as Hitler as well as a video work, in which he delivers a speech. When I met the artist in early April of this year, he was still working on the wording of the speech, which he was basing on the famous last oration in the movie. He replaced the *hakenkreuz* on the uniform with a character that resembles a Chinese character which means *smile*. The content of the speech would also be much different from Chaplin's version, which starts off with a line, "I'm sorry, but I don't want to be an emperor." Morimura's speech, which he delivers in English, is peppered with a phrase, "I don't want to be a dictator."

"It has been most difficult to find the right way to do this," said Morimura. "It was like crossing a suspension bridge over a deep ravine."

Interestingly, the historic events of the 20th century that interest him all occurred before 1980. It was as if his 20th century ended in the 1970s. Similarly, when he was making the *Actress* series, he reproduced scenes in the movies originally produced between 1920 and 1970. He said that he considered more recent films as the products of the 21st century.

How does he define the 20th century? "I distinctly remember this: when I watched *Star Wars*, I thought something was over, and it was the beginning of something new," said Morimura. In Japan, the phenomenally successful movie was released in the summer of 1978. He saw it in a movie theatre in Osaka. "But I wasn't excited. I didn't think I was going to like that 'something new.'"

To Morimura, the movie symbolized the beginning of the 21st century, the era of what followed: digital technologies, video games and the Internet. As a visual artist who works with the medium of photography, he considers the 20th century as the era of images, or the era when "people had this desire to depict what they saw as they were."

Of course, that desire originated centuries earlier. Johannes Vermeer, the Dutch painter of the pre-photographic 17th century, used optical devices

to add a perspective and realism to his work. The desire to capture and reproduce what they saw eventually resulted in inventions of photography and movies, which was, to Morimura, "very 20th century." When personal computers and digital imaging technologies made it possible to shoot, store the data on the hard disk, and process and edit the images, it was the end of the 20th century.

Perhaps it was his respect for the artists with whom he shares the desire and passion to capture what they saw that moves him; that's what makes him go incredible length in reconstructing masterpieces, great scenes in film, and most recently, journalistic photographs—with a contemporary twist. Morimura's preparations—all the research on his subjects, dresses, costumes, hair pieces, make-up (I was told that putting a make-up for a shoot takes more than five hours), designing the composition—are insanely meticulous. Morimura probably sees himself as the artist of the 20th century.

The 20th century, to Morimura, ended in the 1970s, when he came of age. The personal incidents that connect him with the historic events of the 20th century occurred in the 1960s and 1970s, when he was in his teen and an early adult life. That was when he was hearing about day laborers' riots in Kamagasaki.

So once again, back to Kamagasaki. Shot at night with dozens of lighting devices, the video piece (at least the version that was available at the time of writing this essay) opens with Morimura slowly emerging in the dark. With deep, dark colours accentuated by red flags, the crowd of mostly faceless except for one who stares at us, and the central figure (Morimura/Lenin) showing the left side of his face, the scene immediately reminded me of Delacroix's *Liberty Leading the People*. As far as I know, it was the most dramatic and solemn scene Morimura has ever produced. Has he succeed in appeasing the Susanoo? We will have to see.

Note: All of Yasumasa Morimura's comments in this essay were made in interviews conducted by Itoi. They took place on July 7, 2001 (at the Hara Museum of Contemporary Art, Tokyo), September 30, 2006 (at Shugoarts, Tokyo), March 1, 2007 (in Kamagasaki, Osaka) and April 6, 2007 (at the Yaesu Fujiya Hotel, Tokyo).

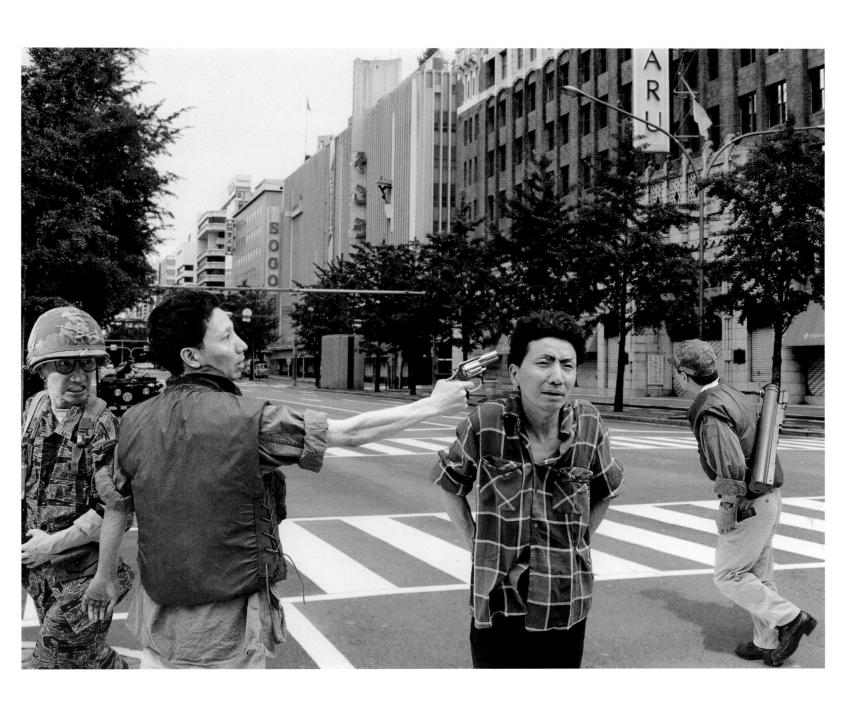

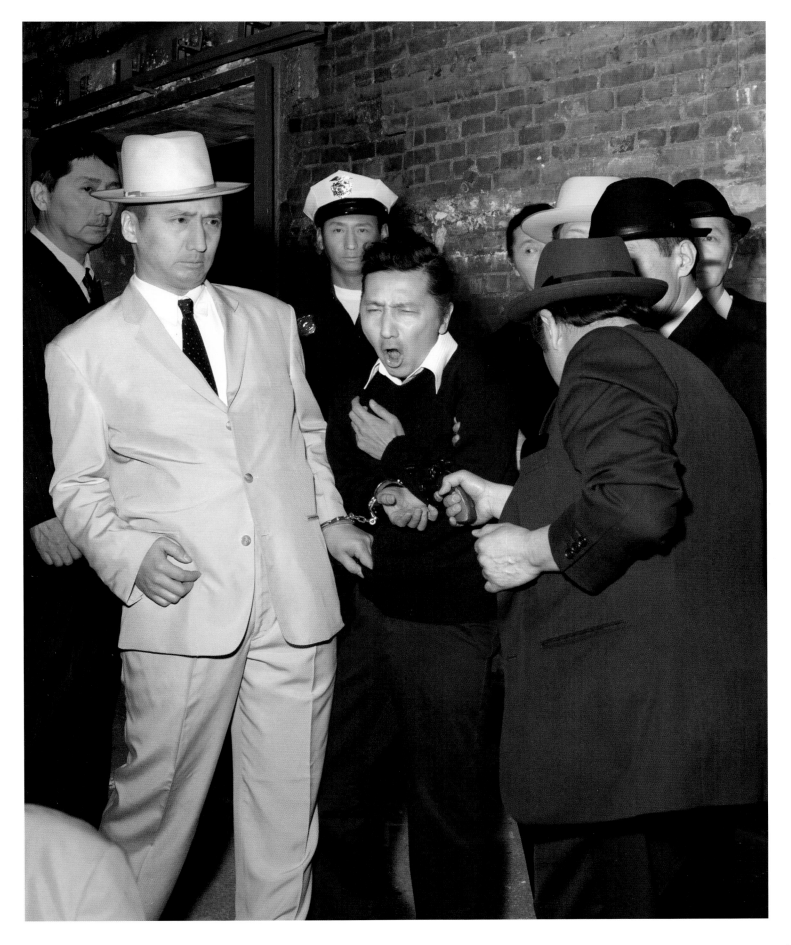

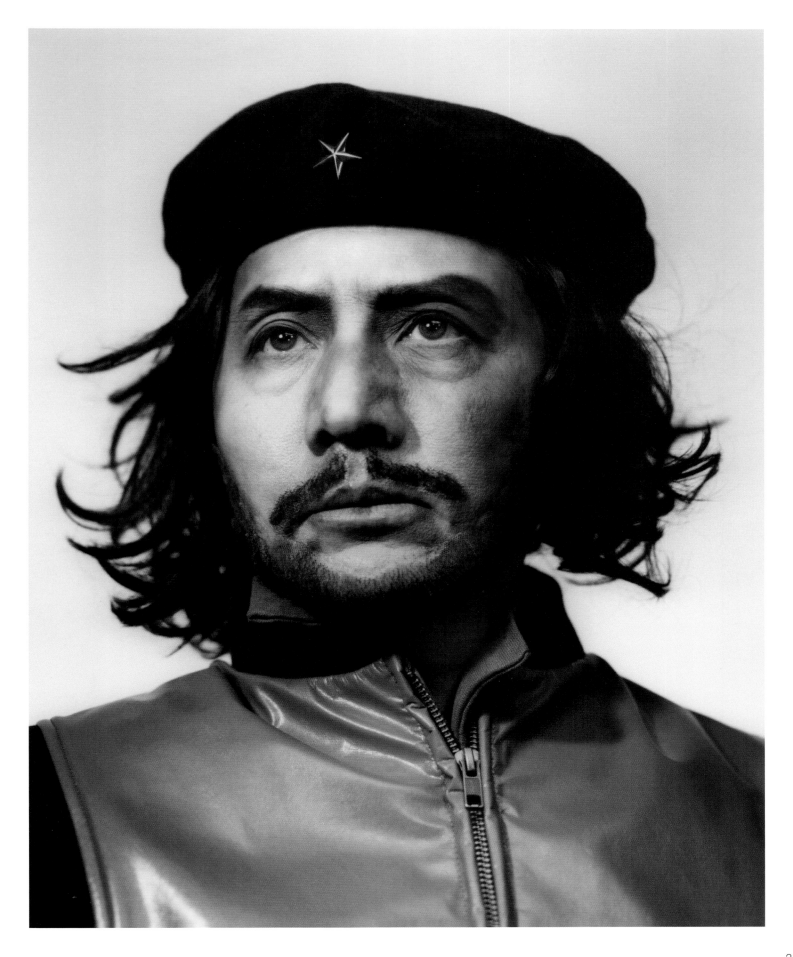

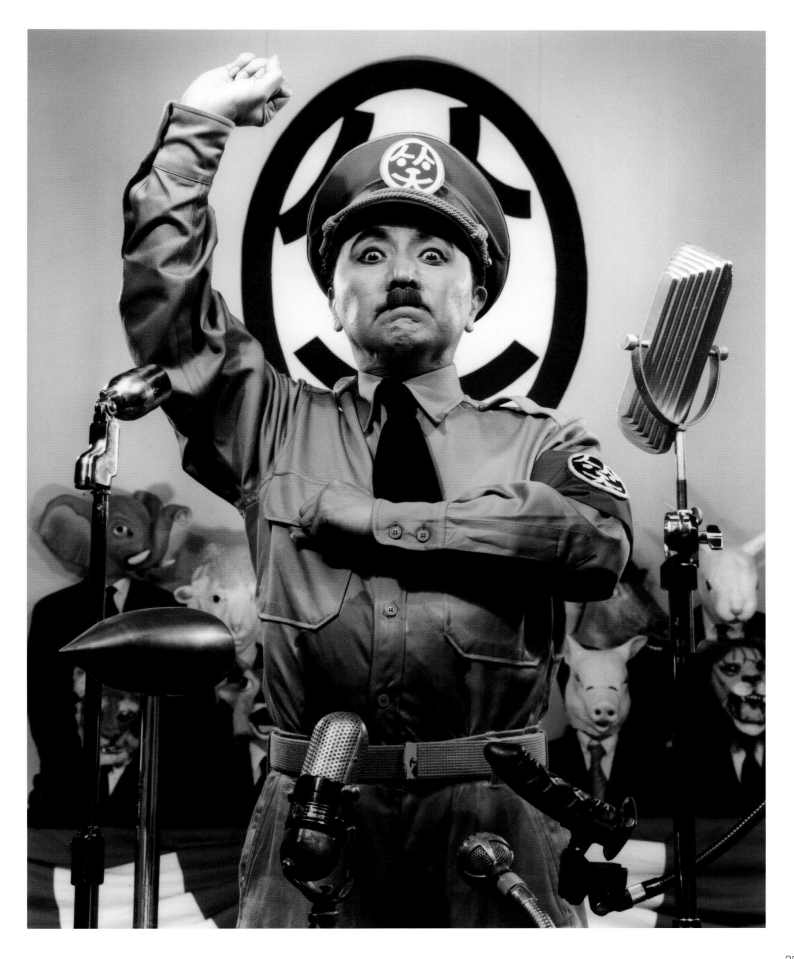

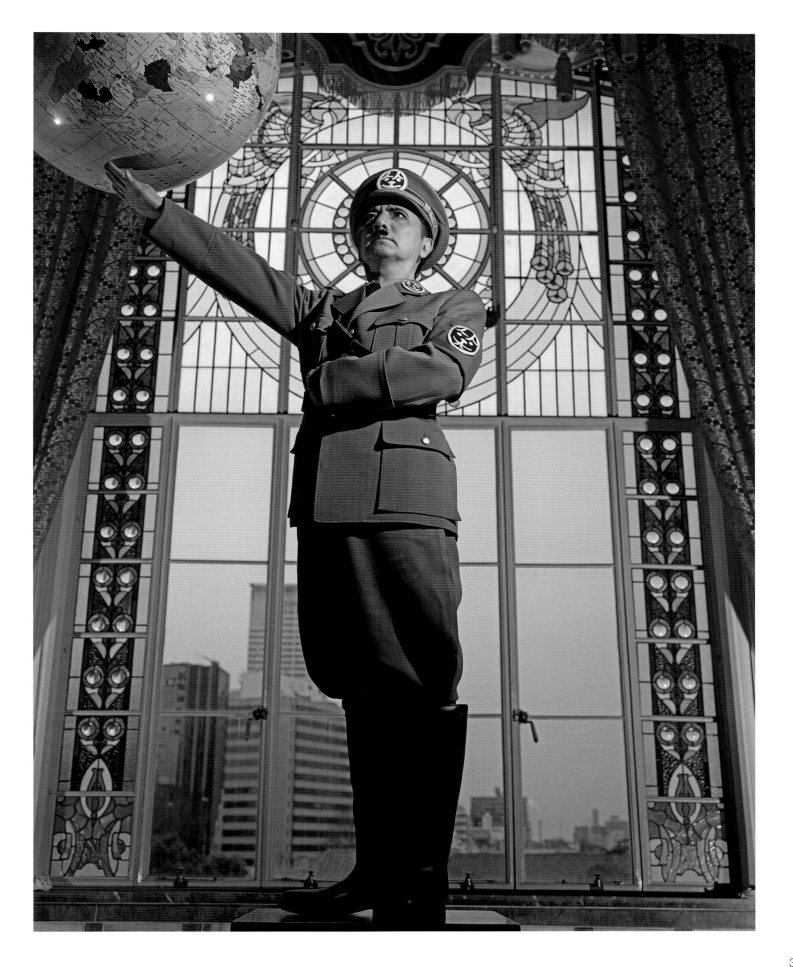

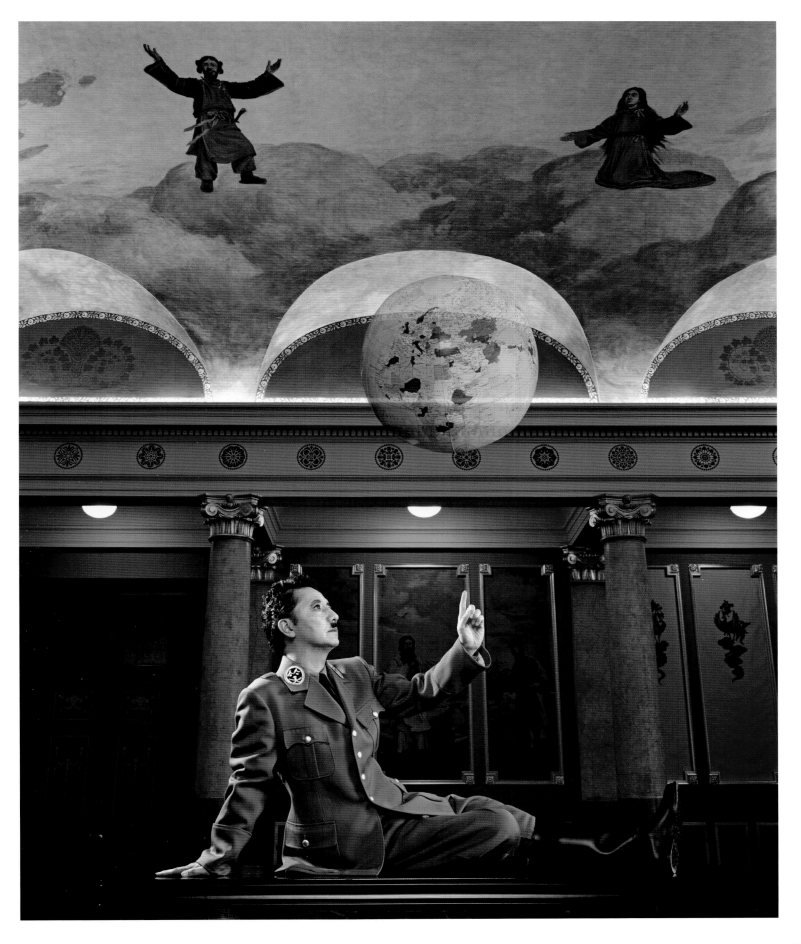

Mr. Morimura's Dictator Speech

I don't want to be a dictator.
A dictator rules the nation and the people alone.
A dictator manipulates many people on his own terms.
A dictator ignores other people's advice.
A dictator forces to change the system he doesn't like.
A dictator high-handedly have people killed when he doesn't like them.
A dictator gets absorbed in amassing personal fortunes.
A dictator's dream is to get everything in the world.

I don't want to be a dictator.
What is a dictator anyway, in the present world where we no longer have Hitler?
Saddam Hussein? Kim Jong-il?
But a large nation itself, not one man, could be a dictator.
It could sometimes threaten small countries with its gigantic military force and gigantic economic power.
A large corporation could sometimes easily buy out small, able companies just in order to make itself richer,
only with manipulation of securities.
The newly invented information processing technique could sometimes lead to easily get rid of wonderful
technologies that are filled with human wisdom and that people have long cultivated.

I don't want to be a dictator.
A certain nation could be,
A certain people could be,
A certain religion could be,
A certain culture could be,
A certain language could be,
A certain corporation could be,
A certain technology could be,
A certain trend could be a dictator of the 21st century.

I don't want to be a dictator.
I look around the world, looking for where a dictator might be.
While I do the looking, I find myself in the mirror.
Looking into the mirror, I ask myself:
"You live in a house equipped with air conditioning.
You eat tasty food.
You utilize convenient transportation to travel.
You utilize convenient information technology to live.
Could you say that you, who do all this, are not a dictator?
Isn't it right that your life is supported by somebody else's death?
Doesn't your life that exists at the expense of somebody else's sacrifice infinitely resembles the life of a
dictator who only cares about his own life?"

You, good citizens,
Have you not been a dictator toward your family, your lover and your friends?
Have you not been a dictator toward flowers, trees, little bugs and stones on the street?
I myself am a dictator.
You yourselves are dictators.
The dictator of the 21st century does not have a face of a bad guy.
The dictator of the 21st century is a ghost that nobody can see.
I don't want to be a dictator.

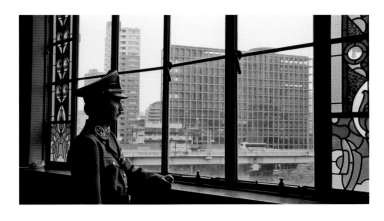

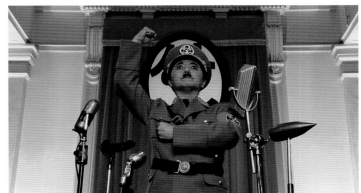

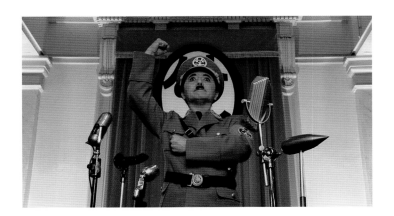

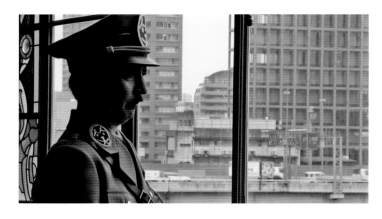

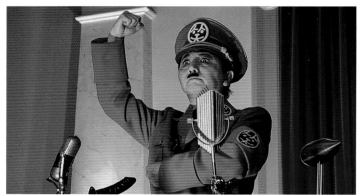

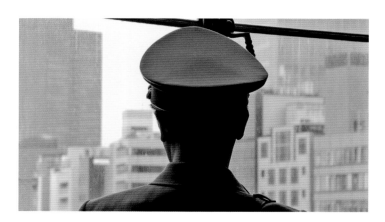

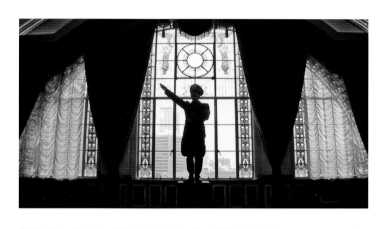

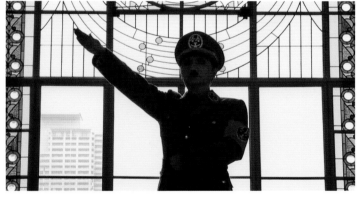

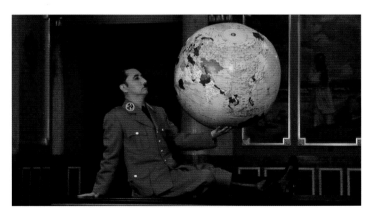

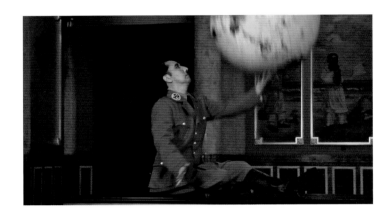

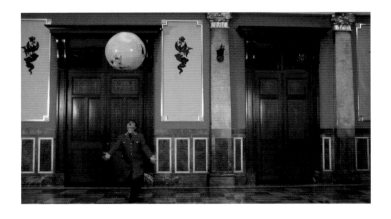

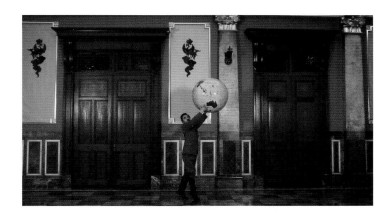

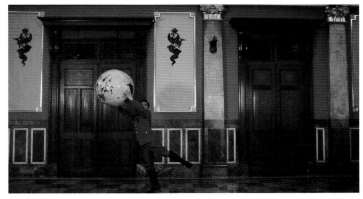

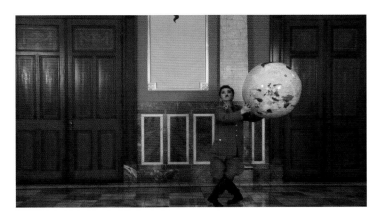

Banzai! Banzai! Banzai! Banzai! Long Live Art! Banzai! Banzai! Banzai!

"True art, for me, is oil painting",[1] and there is no doubt that this statement meant much and influenced the growth and artistic maturation of Yasumasa Morimura since, as a child, he loved dabbling in drawing. Soon Van Gogh and Picasso won out over *ukiyo-e* masters, their masterpieces burnt into the eyes and minds of young artists, replacing Hokusai's prints. All in all, artistic education in Japanese schools promoted the history of western art, from the primordial times of Greek art until the Twentieth century, through the Renaissance, the Baroque, Impressionism, all the way to Duchamp and the Surrealists. Although Morimura had always been aware that his artistic being was inexorably linked to his Japanese roots, it would seem that from the beginning he was incapable of finding the right path that would lead him to developing a style that could be attributed to either one or the other tradition. This conscious lack of balance is manifested clearly in his 1990 work entitled *Daughter of Art History*: *Princess A*, a "manifesto" self-portrayal of the artist, born of the portrait of the Infanta Margarita painted by Velázquez in 1656: Morimura cites this as an example of an altered state of mind, disturbing and in some ways unexplainable, which had wormed its way into him once he had completed his education and which has continued to accompany him in his work.[2]

This invisible discomfort is barely perceptible, for this is how his perfectly polished and scrupulously detailed works appear to the observer's eyes. It is in fact the main characteristic of Morimura, a sort of psychological make-up that the Japanese performer is capable of expressing through his own body and, especially, his own mind, having been trained to look beyond himself whenever Morimura becomes the photographer of the subject instead of being the subject himself, using the lens to frame something which is not in front of him, but which gradually takes form exclusively in his imagination and psyche.

Taro Amano, in his in-depth paper[3] on the series dedicated by the Japanese artist during the mid-1990s to famous starlets that fervidly represented the Western Culture so loved by the Japanese from the end of World War II onward—when Japan truly "discovered" the West, which had previously been described as the devil that would have invaded and destroyed everything, from men to things—, speaks of Morimura's self-portraits as an exercise in self-reflection, underlining the depth of his analysis in his disassembling and reassembling iconic metaphors of beauty into different forms, recontextualizing them in settings and backgrounds that seem to clash with the subject, but instead actually give rise to a new relationship between

two such distant cultures that are often incapable of communicating to each other. In fact, the result is a Vivien Leigh in a garden of blossoms in Kyoto, a Brigitte Bardot riding a motorcycle along the streets of Osaka—Morimura's birthplace—or a Marilyn Monroe posing at Tokyo University. It is important to emphasise how, in addition to seeking new forms of dialogue while hanging in the balance between East and West, the Japanese artist reinvents himself every time. "I have impersonated at least 300 faces. Every time, it is an act of suspending one's self or individuality, releasing the identity of someone else. For me, creating a self-portrait is like exploring the many possibilities I have".[4] Morimura is at once both enchanted and obsessed by the self-portrait (see the exhaustive and exhausting series dedicated to Rembrandt van Rijn, whom he considered as a forerunner for his ability to portray himself and, in doing so, to take another look at reality), from this seeing and simultaneous seeing oneself that allows the artist to reflect the world within.

As for Yukio Mishima—not by chance the first among Twentieth century protagonists of the new *Requiem for the XX Century* series—the extreme attention to detail is unmistakable evidence of the oppressive spell that beauty holds over the artist. But if Mishima charges the stuttering young monk Mizoguchi, the tormented character of *The Temple of the Golden Pavilion*,[5] the burden of setting fire to the Kinkakuji, a fifteenth-century Zen temple in Kyoto, symbol of eternal beauty, thereby believing he will modify the natural order of the world, and above all its "reality," Morimura, every time that he consciously appears through other bodies, demonstrates that he assumes full responsibility for his actions, seeking above all to establish a direct relationship with the spectator who, as captivated as he may be, is at the same time disturbed by what he sees. It recalls, in fact, the series dedicated to the Mona Lisa, or the two versions of the Infant Magarita, or the entire collection of Frida Khalo: in these works, the sublime concept of beauty comes back into discussion, is actualized and reconsidered in the light of many other fundamental themes that regard it today, above all sexuality, cultural identity, and the communicative potential of images. Morimura, who is the first authentic *voyeur* of himself, invites us to use this same intellectual morbidity to observe the mutations around us that constantly intervene.

Just as important is the title that each of his works recites: in contrast to many other artists who have made their own body their tangible field of study —the *Untitled Film Stills* of Cindy Sherman for example, as Taro Amano once again

recalls—, this artist from Osaka indicates his approach to his work with precision, as in the work entitled *An Inner Dialogue with Frida Khalo*, where Morimura inexorably pushes us towards to the discovery of that "grey zone" that is present in every dominion but is only apparently clearly identified, that patch of territory that separates one field from another, the delicate passage and numerous unresolved facets of becoming an adult for example, of leaving youthful carelessness behind us, accepting ourselves for what, at that point, life has demonstrated that we are.

Requiem for the XX Century marks an important, decisive moment in Morimura's artistic production: the canvases of the great masters of art history, from Leonardo da Vinci to Van Gogh, through Rembrandt van Rijn, Velázquez, and Goya, the faces and the bodies of the stars from romantic and captivating movies now relinquish the stage to the faces and bodies of the controversial and turbulent Twentieth century—hence all men, and no longer women. No longer beauty on display, no longer ambiguous sexuality, but rather the unease of the artist catapulted into a present-future that he feels escapes him, that slips away, and that sometimes cannot be condensed into a single image as before, but requires a limpid and precise narrative structure. For this reason, Morimura now adds video to paintings, sculptures, and photography, sensing the need for more intense and direct expressive means capable of exciting, but also of enticing the spectator to participate. Now the dominion is clearly the even wider one of "who are we" and "what have we become" and "where are we going", and it could not be otherwise, considering the selection of personalities collected. The grey zone has now become a mire of inquiries without answers, of questions shouted through the high-pitched voices of the men who have made the history of this past century, whether for better or for worse, to whom Morimura first asks to interrogate the world concerning the destinies of an art that is so compromised by numerous systems that regulate the development and transmission of the contents, too often relegated to a mere and unhappy minor role.

Hence, the passage of Morimura the performer from being both photographic portrait and portrayer to being the star and director of his film is automatic.

Exemplary, in this sense, is the reinterpretation of the speech that accompanies the video inspired by the famous last speech given to military cadets by Yukio Mishima before his death on November 25, 1970 by *seppuku*—ritual Japanese suicide—, following an incredible occupation: "You are artists, aren't

you? If you are, why is it you are so enthralled with forms of expression that deny who you are? Why do you kiss the ass of every passing fad and fancy in Japanese art today, as they undermine your identity? If you keep on like this, nothing can ever save you, nothing." Mishima, who we remember, is the first of the celebrities impersonated, the ideal link between previous female figures and current male leaders because of his aesthetic and sexual ambiguity, obliged to coexist with the solid conviction of the supremacy of being over appearance—first of all lends a voice to the tormented and probably deluded artist, but represents only the extreme and more painful point of the reflections that are at the base of Morimura's new works, resolved in extending his concern to much broader questions that belong to the daily life and struggle of each of us, extending that grey area that, up until a few years ago, was defined more clearly.

Now is it necessary to remember two important assumptions that cannot be avoided when examining this new opus: their genesis and Morimura's point of view. These photographs and videos are works born of images from journalistic archives and meticulously reconstruct the original situation where the fact actually occurred, then reset, as he is wont to do, in a Japanese scenario: the street of Osaka for the famous execution in Vietnam or the run-down quarter of Kamagasaki, always in Osaka, for the replica of Vladimir Lenin's 1920 speech. In addition to the usual search for a relationship between different elements capable of giving life to new interpretations, here the field of research widens: because these are not existing works of art, because these are not stereotyped icons of international glamour, but especially because, in addition to being actual historical facts or men who actually existed, these persons or events have had enormous impact in the formation of civil, social, and political consciousness—and consequentially in Morimura's artistic consciousness. By his own admission, he feels himself a member of the generation of the Twentieth century that he believes ended at the close of the 1970s. In Kai Itoi's contribution to this volume, Morimura claims that the viewing of the film *Star Wars* was "his" breaking point between the XX and the XXI centuries, which he perceived as a looming technological storm that would soon vent itself upon creativity, a phenomenon associated with a new method of communicating —and no longer simply communicate—so immensely distant from him and his artistic *modus operandi,* from his interior time. Morimura's point of view —as a talented craftsman as well as a refined artist—cannot be aligned with the

exasperating rhythm of contemporary art and, especially today, the Japanese artist feels he can no longer accept the rampant daily consumption of images and the consequential dispersion of those capital foundations of art that have nourished him since his adolescence, expressed by that western world that today ignores them and appears to abandon them in favour of a new system that constantly requires new forms—and not content—in order to survive in itself.

In a certain sense, *Requiem for the XX Century*, is a highly intimate work as far as universal questions are concerned, and only the apparent naivety with which Morimura confronts such themes is resolved happily and surprisingly in the effectiveness of the results, sometimes disarming in how they eventually succeed in balancing aesthetic value with ethical value: his Che Guevara and his Mao Tsedong have tired and worn faces that bear decades of contrasting and controversial opinions, their expressions inquire, and seem to ask once again for the consensus of the people who so loved and idealized them, or shake off the hatred of those who fought and opposed them. His Adolf Hitler/Charlie Chaplin tells us that whoever today has a middle bourgeois social standing may be defined as a "dictator" because his well-being is probably due to the suffering of others, and his Vladimir Lenin reminds the public that "humanity is sadly futile."

The elaboration of the experiences of all these cumbersome figures, in his efforts to calm the Susanoo within them,[6] brings Morimura himself beyond the oft-explored "grey zone" for the first time, and towards a new sort of conscious, artistic *seppuku* in the name of Art.

"Banzai! Banzai! Banzai! Banzai! Long Live Art! Banzai! Banzai! Banzai!"[7]

[1] In the volume *Daughter of Art History Photographs by Yasumasa Morimura*, the artist introduces an interesting autobiographical text to his work. This volume is published by Aperture Foundation, New York 2003.
[2] Ibidem.
[3] Taro Amano, chief curator of the Yokohama Museum of Art, in his paper *Can Yasumasa Morimura Save Humanity?*, published in the catalogue *The Sickness unto Beauty* for the occasion of the artist's personal exhibition at the museum of Yokohama in 1996.
[4] From an excerpt of *Interviewing Yasumasa Moritura: A system of endless rebirth*, "Hanga geijutsu", 81, pp. 134–35, also cited by Taro Amano in his paper as cited in note 3.
[5] Yukio Mishima, *nom de plume* for Japanese writer and playwright Hiraoka Kimitake, author of *The Temple of the Golden Pavilion*, (original title, *Kinkakuji*) (1956), Italian edition by Giangiacomo Feltrinelli Editore, Milan 1962.
[6] Susanoo is the God of Storm and Sea in Japanese mithology.
[7] From the text rewritten by the artist to accompany the video inspired by the Mishima's last speech.

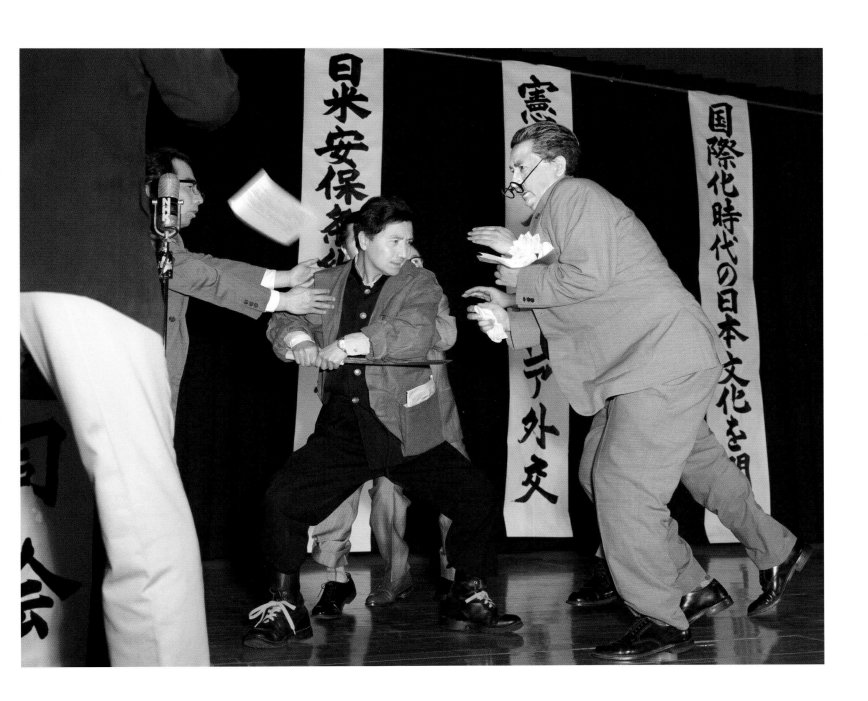

51

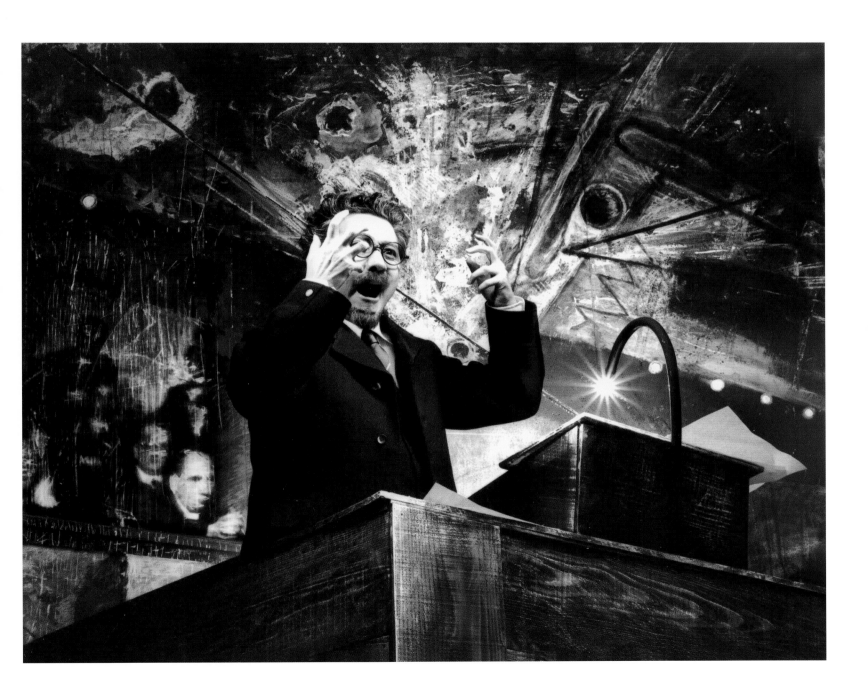

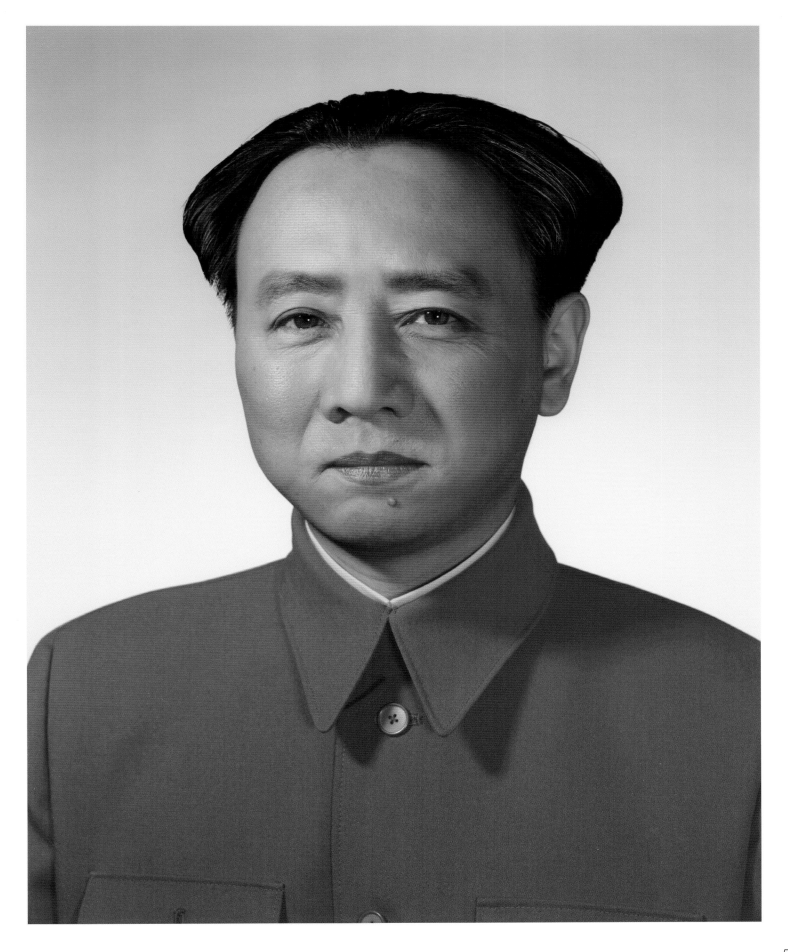

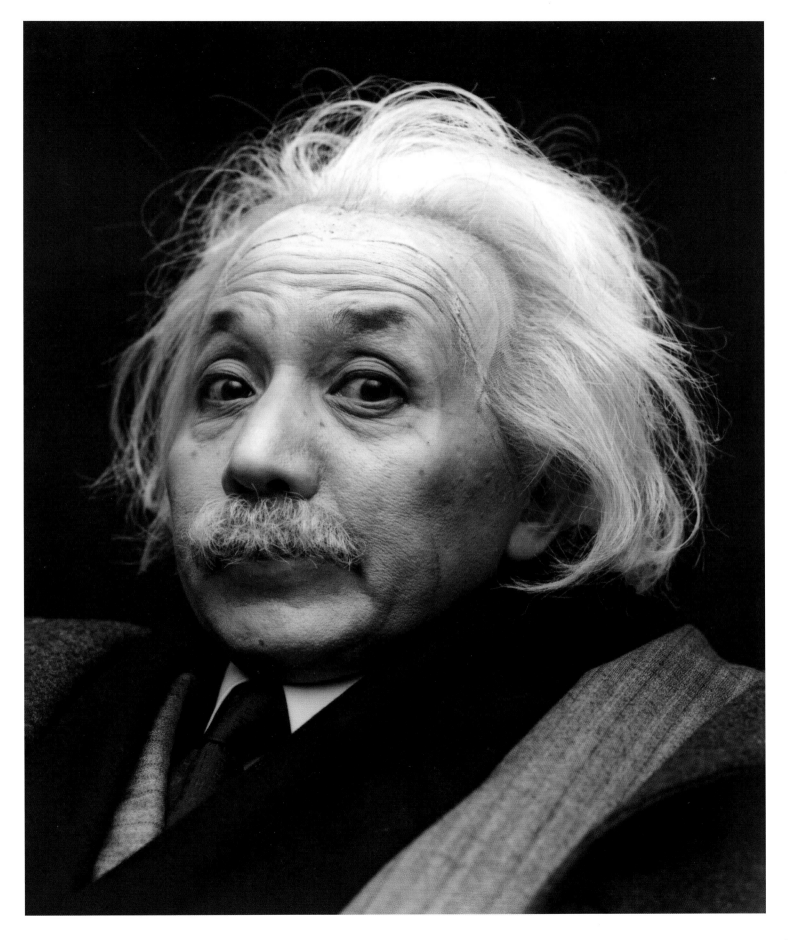

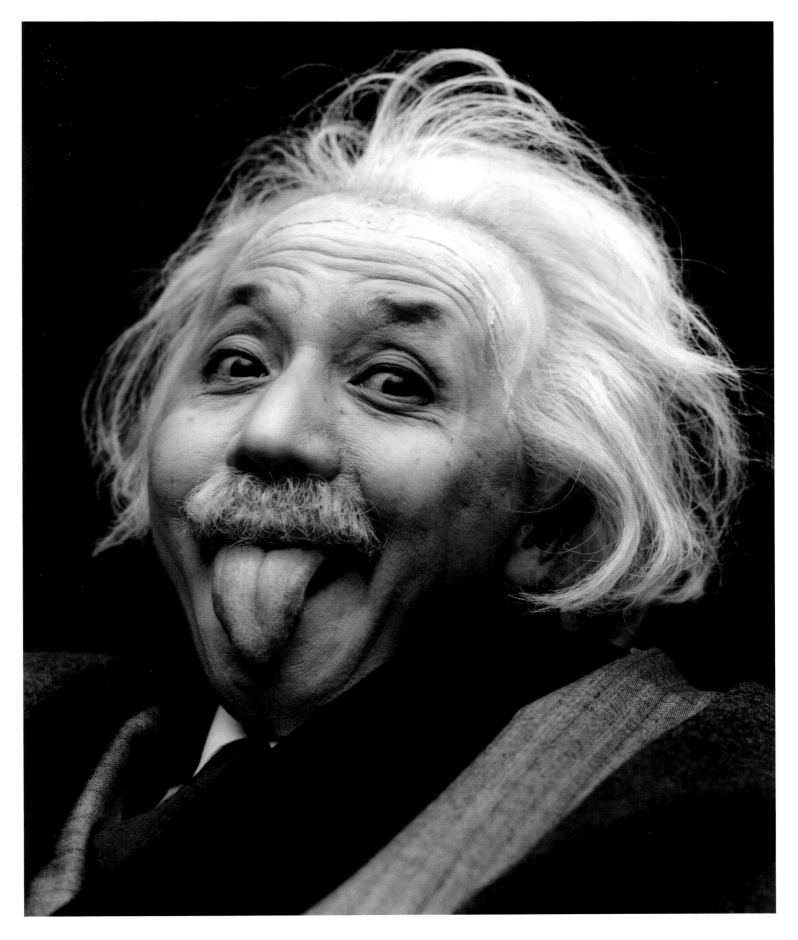

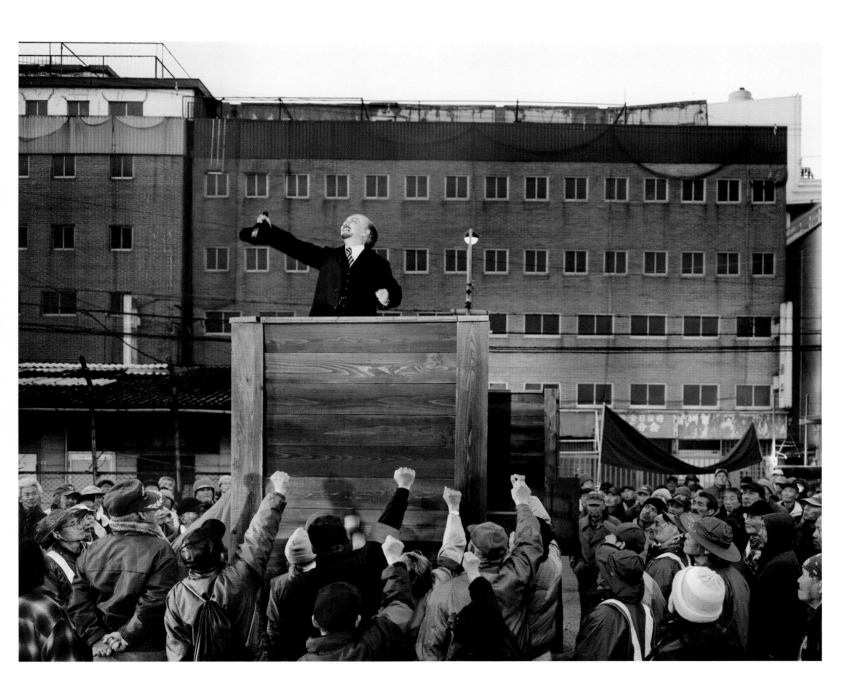

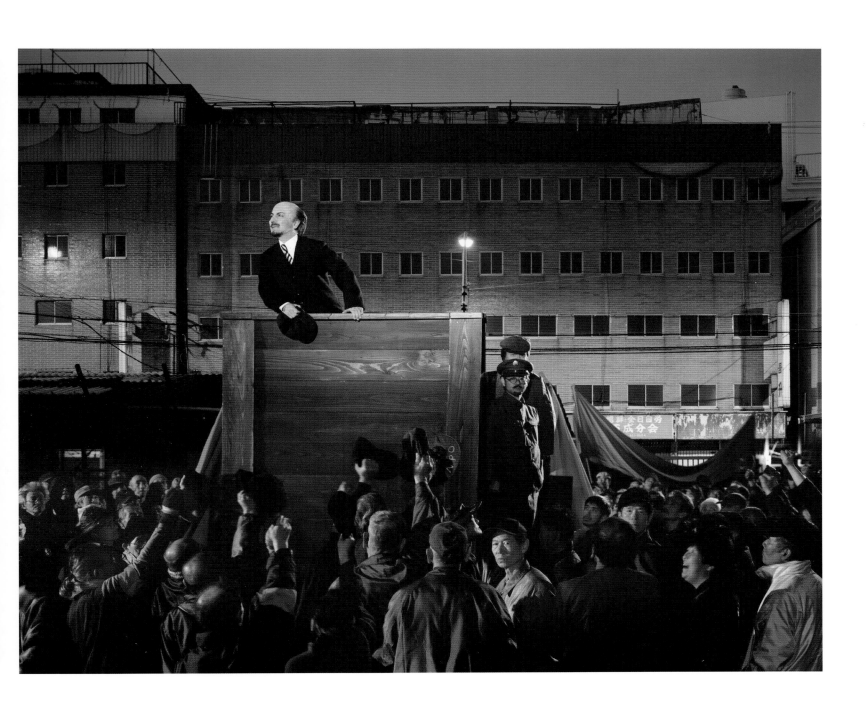

A Requiem: Humanity is Sadly Futile

War is futile
Peace is futile, too
Having power is infinitely futile
Humanity is sadly futile.

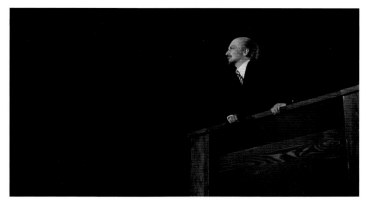

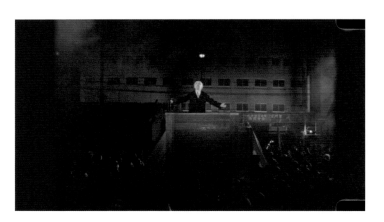

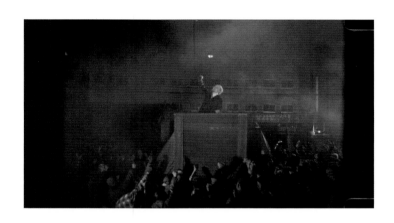

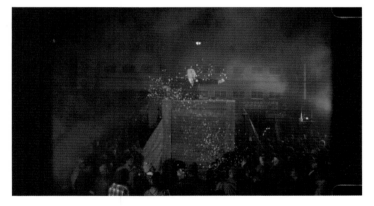

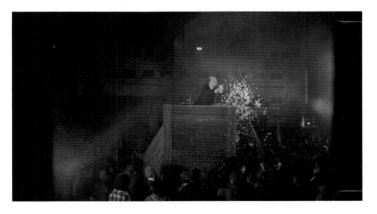

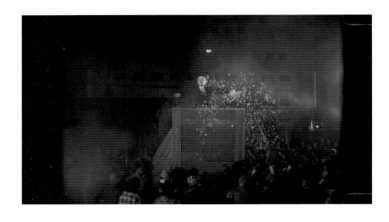

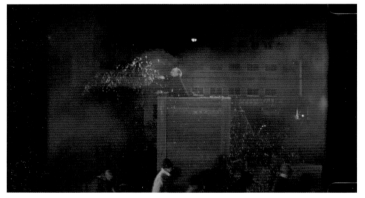

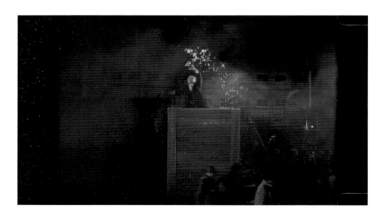

Biography

1951
Born in Osaka.
1978
Education: Kyoto City University of Art.

Awards
The International Research Center for the Arts, Kyoto, artist-in-residence Fellow.

Selected Solo Exhibitions

1983
Galerie Marronnier, Kyoto.
1984
Hiramatsu Gallery, Osaka.
1986
Mon amour violet et autres, Gallery Haku, Osaka.
1988
Gallery NW House, Tokyo.
1989
Criticism and the Lover, Mohly Gallery, Osaka.
1990
Daughter of Art History, Sagacho Exhibit Space, Tokyo (exh. cat.); Nicola Jacobs Gallery, London.
1991
Thomas Segal Gallery, Boston.
Luhring Augustine, New York.
Options 44, Museum of Contemporary Art, Chicago; The Carnegie Museum of Art, Pittsburgh (exh. cat.).
1993
9 visages, Fondation Cartier pour l'art contemporain, Jouy-en-Josas (exh. cat.).
1994
Psychoborg, The Ginza Art Space, Shiseido, Tokyo.
Psychoborg, The Power Plant, Toronto; Walter Philips Gallery, The Banff Center for the Arts, Alberta.
Rembrandt Room, Hara Museum of Contemporary Art, Tokyo (exh. cat.).

1996
The Sickness unto Beauty, Self-portrait as Actress, Yokohama Museum of Art, Yokohama.
Luhring Augustine, New York.
Actress Series, Marugame Genichiro-Inokuma Museum of Contemporary Art, Kagawa.
Actress and Art History, Center for Contemporary Photography, Melbourne.
1997
Actors and Actresses, Contemporary Arts Museum Houston, Texas.
1998
Morimura, Studio Guenzani, Milan.
Morimura Yasumasa Self-portrait as Art History, Museum of Contemporary Art, Tokyo; The National Museum of Modern Art, Kyoto; Marugame Genichiro-Inokuma Museum of Contemporary Art, Kagawa.
1999
White Cube, London.
Daughter of Art History, Luhring Augustine, New York.
The Name with no Name, The Self with no Name, The Center of Academic Resources, Chulalongkorn University, Bangkok.
Yasumasa Morimura: Historia del arte, Fundación Telefónica, Madrid.
Morimura Self-Portraits: An Inner Dialogue with Frida Kahlo, Hara Museum, Tokyo.
Story of M's Portrait, Museum Eki, Kyoto.
Self-Portraits: An Inner Dialogue with Frida Kahlo, Luhring Augustine, N.Y; Galerie Thaddaeus Ropac, Paris.
A Hundred Polaroids, Rice Gallery by G2, Tokyo.

2002
Self-Portraits: An Inner Dialogue with Frida Kahlo, Galeria Juana de Aizpuru, Madrid.
A Story of M's self-portraits, Kawasaki City Museum, Kawasaki.
A Photographic Show of Murmur and Hum, Bunkamura Gallery, Tokyo.
Inside the Studio, Yasumasa Morimura, Japan Society, New York.
Self-Portraits, Cà di Fa, Milan.
SITE SantaFe, Santa Fe, New Mexico.
The Artist's treasures, Shugoarts, Tokyo.
Barco Negro on the table, MEM, Osaka.
Polyhedron of Yasumasa Morimura / Kalei de Scope, B Gallery, Osaka Seikei University.
2005
Los Nuevos Caprichos, Luhring Augustine, NY; Galeria Juana de Aizpuru, Madrid; Galerie Thaddaeus Ropac, Paris; Shugoarts, Tokyo.
One Artist's Theater, Gary Tatintsian Gallery, Moscow.
Season of Passion / A Requiem: Chapter 1, Shugoarts, Tokyo.
An Inner Dialogue with Frida Kahlo, Gary Tatintsian Gallery, Moscow.
Art Classroom: Pay Attention, Contemporary Art Museum, Kumamoto, Japan.
Yasumasa Morimura: Reflections, John Michael Kohler Arts Center, Sheboygan, WI.

Selected Group Exhibitions

1984
Can't You See We Are Not Reticent?, Gallery [vju], Osaka.
1985
Smile with Radical Will, Galerie 16, Kyoto.
1986
The 4th Kyoto Art and Craft Exhibition, Municipal Art Hall, Kyoto.
1987
Panache, ON Gallery, Osaka.
Yes Art deluxe, Sagacho Exhibit Space, Tokyo; Gallery Haku, Osaka.
1987
Photographic Aspect of Japanese Art Today, Tochigi Prefectural Museum of Fine Arts, Utsunomiya.
1988
XLIV Biennale di Venezia, *Aperto '88*, Venice (exh. cat.).
Art Now '88, Hyogo Prefectural Museum of Modern Art, Kobe.
1989
Against Nature: Japanese Art in the Eighties, SFMoMA, San Francisco; Grey Art Gallery and Study Center, New York University Art Collection, New York; Contemporary Art Museum, Houston, Texas (exh. cat.).
1990
Images in Transition: Photographic Representation in the Eighties, The National Museum of Modern Art, Kyoto: The National Museum of Modern Art, Tokyo (exh. cat.).
Japanische Kunst der 80er Jahrer, Frankfurter Kunstverein, Frankfurt am Main; Bonner Kunstverein, Bonn; Hamburger Kunstverein, Hamburg; Kunstlerhaus Bethanien, Berlin; Musuem Moderner Kunst, Wien (exh. cat.).

Japan Art Today: Elusive Perspectives / Changing Visions, The Cultural Center of Stockholm, Stockholm; Helsingen Kaupungin Taidemuseo, Helsinki; Reykjavik Municipal Musuem, Reykjavik.

1991

Metropolis, Martin-Gropius-Bau, Berlin (exh. cat.).

Trans / Mission, Rooseum Center for Contemporary Art, Malmo, Sweden (exh. cat.).

A Cabinet of Signs: Contemporary Art from Post-Modern Japan, Tate Gallery Liverpool; Whitechapel Art Gallery, London; Malmo Konsthall, Sweden (exh. cat.).

1992

Post Human, FAE Musée d'Art Contemporain, Lausanne; Castello di Rivoli, Museo d'Arte Contemporanea, Torino; Deste Foundation for Contemporary Art, Athens; Deichtorhallen, Hamburg, Germany (exh. cat.).

Homage to Spanish Still Life by Yasumasa Morimura & Miran Fukuda, Nagoya City Art Museum (exh. cat.).

1993

Building a Collection, Part 1, Museum of Fine Arts, Boston.

Dress Codes, Institute of Contemporary Arts, Boston (exh. cat.).

Slittamenti, Aperto '93, Venice Biennale, Venice.

1994

Bad Girls, The New Museum, New York (exh. cat.).

Japanese Art After 1945: Scream Against the Sky, Yokohama Museum of Art, Yokohama; Guggenheim Museum SoHo, New York (exh. cat.).

Persona Cognita, Museum of Modern Art, Heide.

Inside Out: Contemporary Japanese Photography, The Light Factory Photographic Arts Center, Charlotte, North Carolina; Kemper Museum of Contemporary Art, Kansas City.

1995

Cocido y Crudo, Museo Nacional Centro de Arte Reina Sofia, Madrid (exh. cat.).

Narcissistic Disturbance, Otis Gallery, Otis College of Art and Design, Los Angeles.

Japan Art Today, Musuem of Modern Art Louisiana, Denmark; Kunstnernes Hus, Oslo; Lijevalchs Konsthall, Stockholm; Deichtorhallen, Hamburg.

More than Real, Royal Palace, Caserta, Italy.

Duchamp's Leg, Walker Art Center, Minneapolis; Center for the Fine Arts, Miami.

1996

The 10th Biennale of Sydney, *Jurassic Technologies Revenant*, Sydney.

Prospect '96, Kunstverein Frankfurt (exh. cat.).

The Hugo Boss Prize: 1996, Guggenheim Museum SoHo, New York (exh. cat.).

Face and Figure in Contemporary Art, Museum of Fine Arts, Boston.

1997

Rose is a Rose is a Rose: Gender Performance in Photography, Solomon R. Guggenheim Museum, New York (exh. cat.).

Sous le Manteau, Galerie Thaddaeus Ropac, Paris.

1 minute scenario, Printemps de Cahors, Saint-Cloud.

Lust und Leere, Kunsthalle Vienna; Arken Museum fur Moderne Kunst, Copenhagen; Kunsthalle zu Kiel, Kiel.

1998

Rene Magritte and contemporary art, an influence on ideas and facts, or the puzzle never solved, Museum voor Moderne Kunst, Oostende.

The 80's, Culturgest, Lisbon.

Technotherapy, City Central Public Hall, Osaka.

1999

Fame: After Photography, Museum of Modern Art, New York.

Regarding Beauty in Performance and the Media Arts, Hirshhorn Museum and Sculpture Garden, Washington; Haus der Kunst, Munich.

Kunstwelten im Dialog, Museum Ludwig, Cologne.

2000

Zona F, Espai d'art Contemporani de Castello, Castello, Spain.

The 3rd Gwangju Biennale Special Exhibition, *Human and Gender*, Gwangju (exh. cat.).

World Without End: Photography and the 20th Century, Art Gallery of New South Wales, Sydney.

Gendai: Japanese Contemporary Art-Between the Body and Space, Center for Contemporary Art, Ujadowski Castle, Warsaw (exh. cat.).

2001

Yasumasa Morimura, Sawako Goda, Kochi Prefectural Museum (exh. cat.).

The 1st Valencia Biennale, *The body and the sin*, Valencia (exh. cat.).

Abbold: Recent portraiture and depiction, Steirischer Herbest, Graz (exh. cat.).

Tableaux Vivants, Kunsthalle Wien, Wien (exh. cat.).

Two of Us, L.A. Galerie Lothar Albrecht, Frankfurt am Mein.

The Floating World and Beyond, Weatherspoon Art Museum, The University of North Carolina, Greensboro, NC.

Future Plan, Hyogo Prefectural Museum of Art, Kobe.

2003

Happiness, Mori Art Museum, Tokyo (exh. cat.).

Supernova: Art of the 1990s from the Logan Collection, SFMoMA, San Francisco.

Influence, Anxiety & Gratitude, MIT List Visual Arts Center, Cambridge, MA.

Genomic Issue(s): Art and Science, The Graduate Center of the City University of New York, New York.

The History of Japanese Photography, Museum of Fine Arts, Houston (exh. cat.).

Role Play Self-Portrait Photography, Zabriskie Gallery, New York, NY.

2004

Made in Mexico, Institute of Contemporary Art Boston, Boston (exh. cat.).

Disguise, Manchester City Galleries, Manchester.

Takarazuka: The Land of Dreams, Suntory Museum, Osaka; Tokyo Opera City Art Art Gallery, Tokyo; Sogo Museum, Yokohama (exh. cat.).

20th Anniversary Exhibition: The Copy Age-From Duchamps thorough Warhol to Morimura, The Museum of Modern Art, Shiga (exh. cat.).

Commodities Celebrities Death & Disaster, Salina Art Center, Kansas.

Confronting Tradition: Contemporary Art from Kyoto, Smith College museum of Art, Northampton, MA.

Camouflage, Surrogates, and Other Divisionary Tactics, The Rashofsky House, Dallas, TX.

Maestros in Early Period, Ota Fine Arts, Tokyo.

Marilyn: From Anastasi to Weege, Sean Kelly Gallery, New York.

The Pretenders, Henry Art Gallery, Seattle, WA.

Revisiting History. Self-Portrait Photography, Cristinerose Josee Bienvenu Gallery, New York.

2005

Here Comes the Bogey-Man, Chelsea Art Museum, New York.

Rising Sun, Melting Moon. Contemporary art in Japan, The Israel Museum, Jerusalem.

Post Modern Portraiture, The Logan Collection Vail, CO.

2006

Portraits of Artists: A selection of photographic works from the collection of Rex Capital, Rhode Island. In collaboration with Olivier Renaud-Clement, Luhring Augustine, New York.

Masquerade: Representations and the self in contemporary art, Museum of Contemporary Art, Sydney, Australia (exh. cat.).

Living the Material World Things in Art of the 20th Century and Beyond, group exhibition at New National Art Center, Tokyo.

An Incomplete World: Works from The UBS Art Collection, The Art Gallery of New South Wales in Sydney, Australia.

Celebrity, Scottsdale Museum of Contemporary Art, Scottsdale, AZ (exh. cat.).

Bibliography

Publications

"Kisekae Ningen No.1,"
Shogakukan, 1994.
"Rembrandt's room,"
Shinchosha, 1994.
"A Story of M'sself-portaits,"
Tokyo 1998.
"Daughter of Art History,"
Aperture, New York 2003.

Exhibition catalogue

The sickness unto Beauty, Self-portrait as Actress, Yokohama 1996.
Tastes and Pursuits: Japanese Art in the 1990s, New Delhi 1998.
Self-portrait as Art History, Asahi shinbun, Tokyo 1998.
Art History; Yasumasa Morimura, Foundación Telefónica, Madrid 2000.
Self-Portraits: An Inner Dialogue with Frida Kahlo, Hara Museum, Tokyo 2001.
Yasumasa Morimura. Los Nuevos Caprichos, New York 2005.
Yasumasa Morimura, with Luhring Augustine, Moscow, Gary Tatintsian Gallery, New York 2006.

Selected Bibliography

1990
M. Brenson, "When self consciousness became king," *The New York Times*, February 18.
C. Lutfy, "Morimura: Photographer of Colliding Cultures," *International Herald Tribune*, March 2.
"Gaining Face: Japan's Artists Emerge," *Artnews*, March, pp. 142–47.
E. Heartney, "Mixed Messages,"

Art In America, April, pp. 213–18.
Larson, Kay, "Made in Japan," *New York Magazine*, October 1, pp. 63–4.
1991
N. Messler, "Berlin: 'Metropolis'," *Artforum*, Summer, pp. 101–03.
A. Graham-Dixon, "worlds Apart," *The Independent*, November 12, p. 16.
C. Hagen, "Yasumasa Morimura at Luhring Augustine," *The New York Times*, November 29.
L. Buck, "A Double Take," *The London Times Sunday Magazine*, December 8.
K. Levin, "Voice Choices: Yasumasa Morimura," *The Village Voice*, Dicember 10.
1992
"Japan Today," *Flash Art*, March/April, special edition focusing on Japanese contemporary art, including articles and interviews by F. Bonami, "Yasumasa Morimura: Double Exposure".
A. Munroe, *Wandering Position*, in F. Nanjo, N. Sawaragi, *Dangerously Cute*.
R. Mahoney, "Yasumasa Morimura," Arts, March, p. 83.
P. Plagens, "The Great Impersonator," *Newsweek*, April 6, pp. 62–3.
S. Snodgrass, "Yasumasa Morimura at the Museum of Contemporary Art," *Art in America*, May, p. 133.
W. Zimmer, "Appropriation: When Borrowing From Earlier Artists Is Irresistible," *The New York Times*, June 14.
D. Friis-Hansen, "Miran Fukuda and Yasumasa Morimura," *Flash Art*, Summer.
D. Morera, "Metissage," *Vogue*

Italia, July, p. 171.
G.K. Fiero, *The Humanistic Tradition: The Global Village of the Twentieth Century*, published by WCB Brown & Benchmark, Madison, Wisconsin, pp. 156–58.
1993
C. Hegen, "Reinventing the Photograph," *The New York Times*, January 31, pp. 1–29.
"New Season Shows at the Foundation Cartier," *Flash Art*, May/June, p. 102.
Baker, Kenneth, "When clothes don't make the man," *San Francisco Chronicle*, May 24.
"Yasumasa Morimura: New Image Techinique," *BT*, July, pp. 1–9.
J. Drucker, "Simulation/Spectacle: Beyond the Boudaries of the Old Avant-Garde and Exhausted Modernism," *Third Text*, Summer, pp. 3–16.
P.J., "Docteur Jekyll et Mr. Morimura," *Connaissance des Arts*, No. 493, November, pp. 104–07.
R. Perree, "Morimura Dringt de Westerse Kunst Binnen," *Kunstbeeld*, No. 5, pp. 36–38.
F. Miller Koslow, "Currents '93: Dress Codes," *Artforum*, November.
1994
N. Bryson, "Mother (Judith II)," *Artforum*, No. 70, January.
H. Harrison, "Wit on Wry: Humor in Photography," *The New York Times*, Dicember 26.
K. Lipson, "A Barrel of Photographic Laughs: Absurdity on Film," *Newsday*, December 31.
H. Cotter, "Lest We Forget: On Nostalgia," *The New York Times*, May 27.
"Japan's Avant-Garde Makes Its

Own Points," *The New York Times*, September 16.
P. Plagens, "Living On Tokyo Time," *Newsweek*, September 26.
M. Stevens, "Made in Japan," *New York*, September 26, pp. 109–10.
A. Brown, "The Divided Narcissu," *World Art*, November.
"From Beyond the Pale," *Flash Art*, November-Dicember, p. 36.
1995
D. Friis-Hansen, "Yasumasa Morimura, Rembrandt Room," *Frieze*, January, pp. 57–58.
B. Weil, "Territories: Yasumasa Morimura," *Atlantica*, January, pp. 138–143.
N. Bryson, "Morimura 3 Readings," *Art+Text*, No. 52.
E. Turner, "Exhibit Shows How Many Artists Stand on Duchamp's Leg," *The Herald*, Dicember 3, pp. 11–21.
1996
J. Cantor, "The Artist Stripped Bare," *The New York Times*, February 8, pp. 63–65.
L. Gumpert, "Glamour Girls," *Art in America*, July, pp. 62–65.
1997
J. Annear, "Peepshow: Inside Morimura's Looking Glass," *Art Asia Pacific*, No. 13.
1998
Ulf Erdmann Ziegler, "Männergabd am Schoss der Olympia," *Art*, No. 2, February, pp. 44–50.
D. Bacque, *La Photographie plasticienne*, Édition du regard, Paris.
Fetishes & Fetishisms, Passage de Retz, Paris.
2000
J. Goodman, "Yasumasa Morimura, Daughter of Art

History," *Contemporary Visual Arts*, No. 26.

C. Caujolie, "Trasnsformiste et Iconoclaste," *Mixt(e)*, Autumn, pp. 45–46.

2001

"Morimulacan," *If magazine*, primtemps-été, pp. 94–101.

"Yasumasa Morimura meets Frida Kahlo," *BT*, September, pp. 97–108.

B.A. Pappalardo, "Reviews: Yasumasa Morimura," *Tema Celeste*, November-Dicember, p. 78.

E. Reinhard, "Morimura," *Kunstforum*, No. 157, November-Dicember, pp. 405–06.

N. Princenthal, "Yasumasa Morimura at Luhring Augustine," *Art in America*, Dicembre, pp. 110–11.

"Abracadabra Morimura," *Vogue France*, No. 819, August.

2002

M. Navarro, "Morimura versus Frida Kahlo," *El Mundo El Cultural*, February 27, pp. 26–27.

A. Masoero, "Sussurri e Frida," *Vernissage, il fotogiornale dell'arte*, July-August, No. 29, p. 18.

"Gender and Power in the Japanese Visual Field," Interview with Noi Sawaragi, *Kirin Art Newsletter*, Vol. 3, University of Hawaii Press, Honolulu.

2003

K. Tsuzuki, *Reflex: Contemporary Japanese Self-Portraiture*, Trolley Ltd, London.

E. Brown, "A portrait of the artist as a lady," *Cartier Art magazine*, No. 6, pp. 74–77.

"Curve. The Female Nude Now," Universe, pp. 148–49.

S. Penalas, "Mythology and Genealogy," *Autorretratos, Self-Portraits*, Exit No. 10, pp. 68–73.

S. West, *Portraiture*, Oxford History of Art, Oxford, p. 211.

2004

S. O'Brien, "The great pretender," *Pol/Oxygen*, No. 8, pp. 38–45.

Photography Plasticienne, L'extréme Contemporain, Edition du Regard, Paris.

R. Hirsch, *Exploring Color Photography. From the Darkroom to the Digital Studio*, edition McGraw Hill, New York, p. 227.

La Gui Cas Madrid para el arte ahora mismo, Madrid.

P. Manson, *History of Japanese Art*, 2nd edition revised by Donald Dinwiddle, Pearson Prentice Hall, Upper Saddle River.

G. Williams, "What Are you Looking At," *TATE ECT.*, No. 2, Autumn, pp. 26–33.

W. Shearer, "Portraiture," Oxford History of Art, pp. 204–11.

2005

"Yasumasa Morimura: Kisekae Ningyono Kawaranai Seikatsu," Composite No. 34, June.

ART TOUCH, February, No. 2.

J. Drucker, *Sweet Dreams: Contemporary Art and Complicity*, Chicago.

R. Massengill, *Self-Exposure: The Male Nude Self-Portrait*, New York.

A. Mahon, *Eroticism & Art*, New York, pp. 262–63.

T. Murakami, *Little Boy The Arts of Japan's Exploding Subculture*, New York, p. 275.

Nir Hod: Forever, Tel Aviv Museum of Art, Tel Aviv, p. 227.

L. Spagnesi, "L'arte e Pura Illusione," *ARTE*, August, pp. 36–41.

2006

"Femme, Homme – Prisonniers de Notre Genre?," *Le Monde 2*, No. 109, March 18.

M. Kasahara, "Gendai Self-Portrait," *Nihon Keizai Shimbun*, September 25.

"Seeking the Origin of a Beautiful Nation," *Mainichi Shimbun*, September 30.

"Cheeky Morimura re-creates momentous times," *International Herald Tribune*, November 17.

"Art Tankyuu," *Nihon Keizai Shimbun*, November 18.

"Leaving Behind A Memoir of the 20th Century," *Nihon Keizai Shimbun*, November 18.

A. Kurosawa, "Requiem for Men," *Sankei Shimbun*, November 22.

"Men's Twentieth Century," *Shuukan Asahi* (*Asahi* Weekly), Dicembre 8.

N. Sawaragi, "ART: Yasumasa Morimura," *High Fashion*, No. 312, Dicember.

"Yasumasa Morimura: Yasei no Wa Youshiki," *Ri-ku-u*, Winter.

Symphony of Landscape, Collection Guidebook Shizuoka Prefectural Museum of Art.

ARTCO magazine, No. 166, July, pp. 124–27.

M. Desmond, "From today photography is dead: Portraiture in the digital age", *ART* 198.

M. Guillemot, *L'Art Moderne et Contemporain*, Paris, pp. 260–94.

"Impressions of Self," *DRIVEN*, March, 12.

K. Itoi, "Season of Passion," *artnet.com*.

F. Richer, M. Rosenzweig, *No.1 First Works by 362 Artists*, New York.

"Yasumasa Morimura," *NY Arts Magazine International*, Vol. 11, No. 11/12, p. 292.

2007

Y. Morimura, *Utsukushii tte nandarou?* [What is beauty?], Rironsha.

L. Caruso (ed.), *Radar: Selections from the Collection of Vicki and Kent Logan*, Denver, pp. 126–29.

M. Reilly, L. Nochlin (eds.), *Global Feminisms: New Directions in Contemporary Art*, London & New York.

C. Sakaguchi, "Yasumasa Morimura: Seasons of Passion / A Requiem: Chapter 1", *Art Review*, No. 9, February, p. 137.

The Magazine, February/March, p. 58.

Biographical notes

Filippo Maggia

Born in Biella in 1960, he lives and works in Milan and Turin. From 1993 to 2005 he was the photography curator at the Civic Gallery of Modena. From 1998 until 2004 he was the Editor-in-Chief for Baldini Castoldi Dalai of the *Fotografia come Linguaggio* series. From 2004 to 2006 he was the editorial director for Nepente Editore. Since 2006, he has been editor for the publisher Skira. Since 1998, he has been curator for Italian photography and the photographic collection at the Sandretto Re Rebaudengo Foundation of Turin. In 2000 and 2001 he was invited by the Luigi Pecci Centre for Contemporary Art in Prato to be guest curator. From 2001 to 2004 he took part in the Scientific Committee of the Bologna Gallery of Modern Art. Since 2001, he has collaborated with Rai, Radio3 Suite, where he conducts the programme *Talking Pictures*. From 2002 to 2006 he was the curator responsible for the photographic collection of the Sella Foundation of Biella. President of the jury for the 2004 Hasselblad Award, for which he had already been a member in 2003. In 2004, he was invited by the San Francisco Institute of Fine Art and by the California College of Art to give some lectures on Italian photography. Since 2006 he has been the photography curator for the Bevilacqua La Masa Foundation in Venice. In 2007 he received a visiting fellowship from the Royal College of Art in London for research on the New Photography in Britain. He now teaches History of Contemporary Photography and Design at the European Institute of Design in Turin. He collaborates with art periodicals in Italy and abroad, including the American *Aperture* and the Spanish *Exit*, *Il Giornale dell'Arte*, *Tema Celeste* and the glamour magazine *Flair*. During recent years he has organised several collective and personal exhibitions for museums and institutes. These include the following: *Northern Lights Reflecting with Images* (works by E. Brotherus, A. von Hausswolff, S. Jones, W. Niedermayr, S. Tykkä, Walker and Walker), *The Ancient Sound of the Image* (works by N. Araki, T. Imai, T. Matsue, T. Shibata, H. Sugimoto), *Instant City, fotografia e metropoli* (works by T. Struth, G. Basilico, K. Kitajima, P. diCorcia, H. Starkey, B. Michailov, R. Singh, H. Bond, J. Hanzlovà, Andreoni_Fortugno, F. Jodice) and personal exhibitions of Thomas Ruff, Tracey Moffatt, Philip-Lorca diCorcia, Nobuyoshi Araki, Raghubir Singh, Gabriele Basilico.